D0904152

descent

ter these things, joseph of arimathea, who was a disciple of jesus, though a secret one ecause of his fear of the jews, asked pilate to let him take away the body of jesus. pilate ave him permission; so he came and removed his body. nicodemus, who had at first come jesus by night, also came, bringing a mixture of myrrh and aloes, weighing about a undred pounds. they took the body of jesus and wrapped it with the spices in linen cloths, ccording to the burial custom of the jews. now there was a garden in the place where he ad been crucified, and in the garden there was a new tomb in which no one had ever been id. and so, because it was the jewish day of preparation, and the tomb was nearby, they id jesus there.

hn 19: 38–42

the earliest images of the descent from
the cross simply show the two characters
mentioned by the gospels who helped bury
christ's body: joseph of arimathea and
nicodemus. in later versions of the scene,
there is often a traditional allocation of
roles: nicodemus is shown removing the
nails from christ's feet or hands while
joseph supports the body on his shoulder.

illuminated manuscript —
c.850–900
bibliothèque municipale, angers

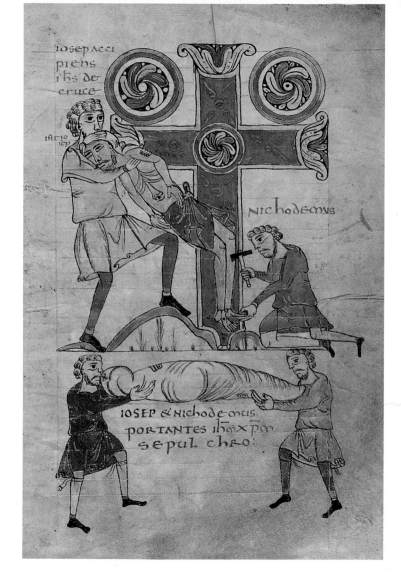

illuminated manuscript

c.980

stadtbibliothek, trier

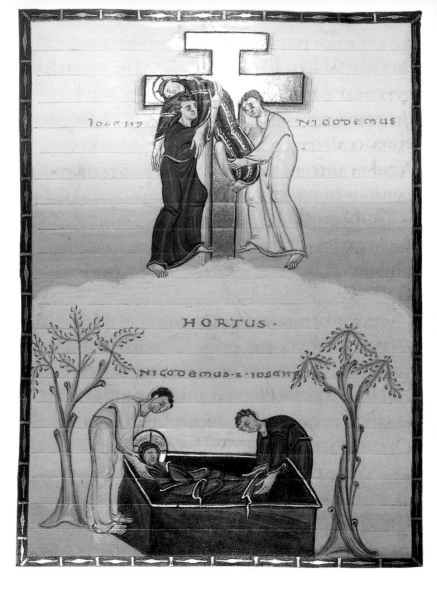

Ioseph
NICODEMUS

HORTUS·

NICODEMUS·Z·IOSEPH

by the eleventh century, western art had
absorbed from byzantine sources the
figures of mary and john, who were
present at the crucifixion. mary can often
be seen holding christ's right hand which
is already free from the cross, and the
apostle john stands slightly apart in an
attitude of sorrow.

wooden panel
c.1050
staatliche museen zu berlin

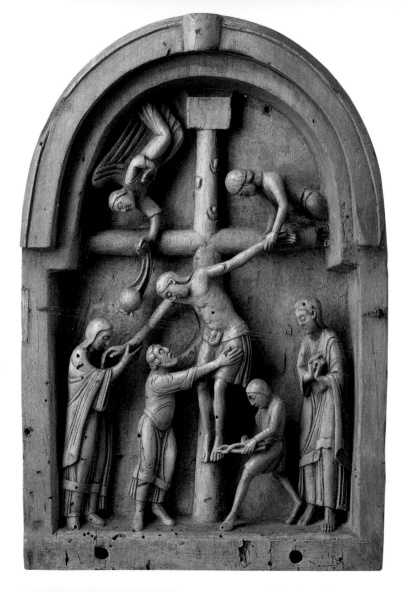

medieval writers, seeking to establish a
link between man's expulsion from
paradise and the redemptive nature of
christ's sacrifice, often asserted that the
crucifixion took place at the site of adam's
burial. here adam is shown coming back to
life and lifting up the lid of his tomb.

stone relief
c.1085–1100
san domingo de silos, spain

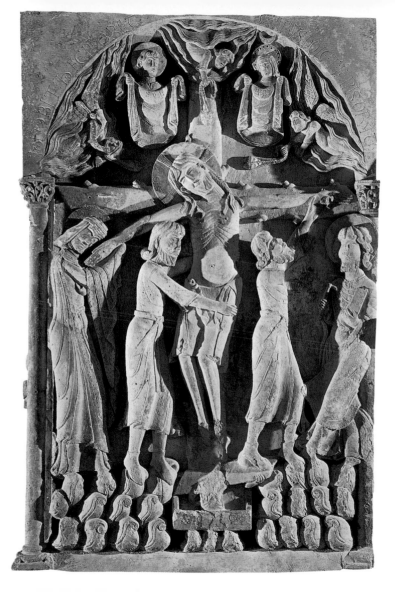

in early versions of the scene, the cross is
low enough for joseph of arimathea and
nicodemus to be able to remove christ's
body while standing on the ground. as the
cross increases in height, a ladder becomes
more of a necessity.

basilius of jerusalem
illuminated manuscript
1131–43
british library, london

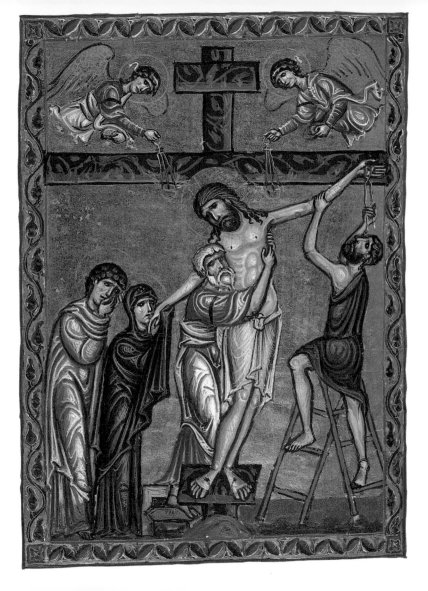

stained-glass window
c.1150
chartres cathedral

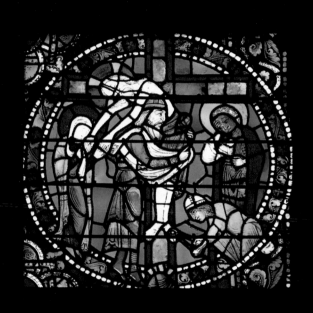

english school

ivory plaque

c.1150

victoria and albert museum, london

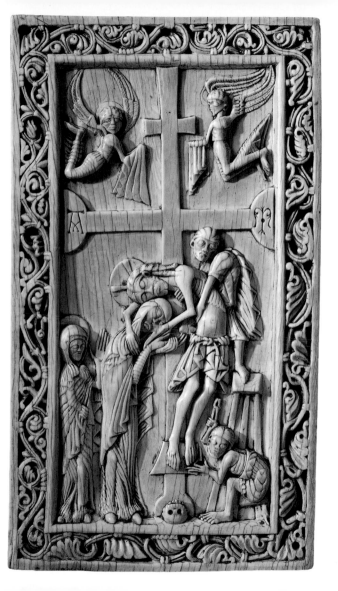

rhenish school
bronze reliquary with rock crystal
c.1150
victoria and albert museum, london

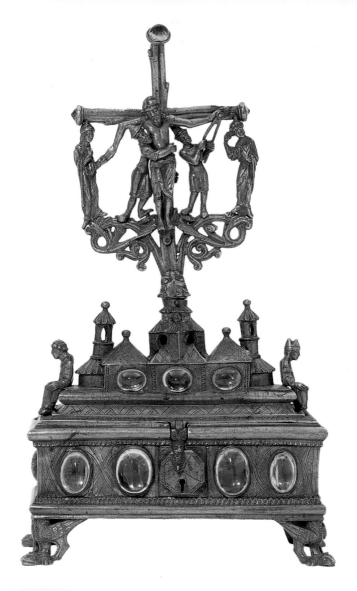

fresco

1164

saint panteleimon, nerezi

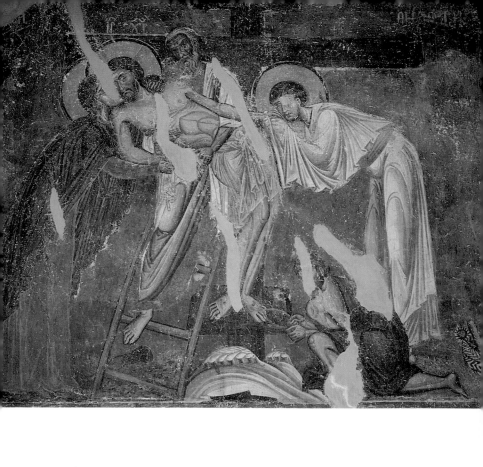

from the mid-eleventh century onwards,
artists tended to include more figures in
their pictures of the descent from the
cross – usually those associated with the
crucifixion. antelami's relief includes
personifications of the church (below
christ's right arm, holding a chalice) and the
synagogue (under the ladder, with bowed
head and broken banner), the centurion, and
the soldiers gambling over christ's garment.

benedetto antelami
marble relief
1178
parma cathedral

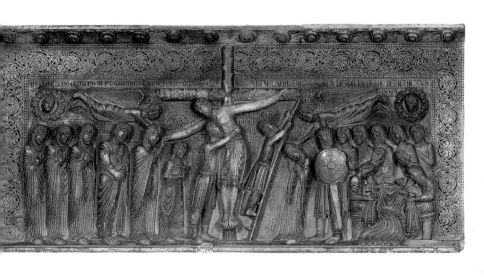

illuminated manuscript
late 12th century
staatsbibliothek, berlin

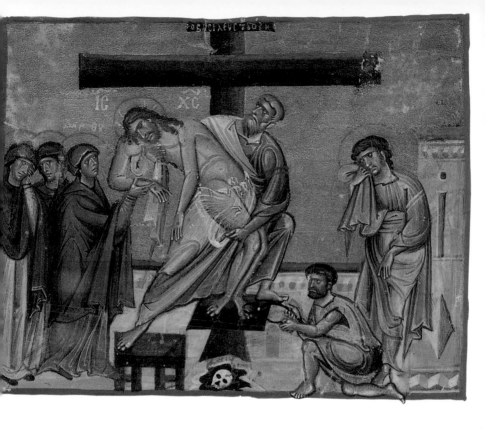

french school
enamelled silver-gilt tabernacle
c.1220
metropolitan museum of art, new york

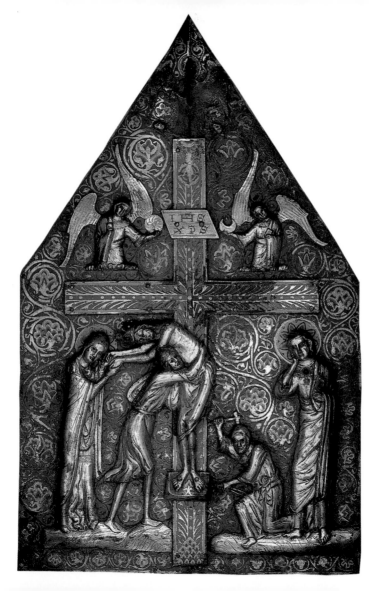

wooden sculpture
13th century
tivoli cathedral

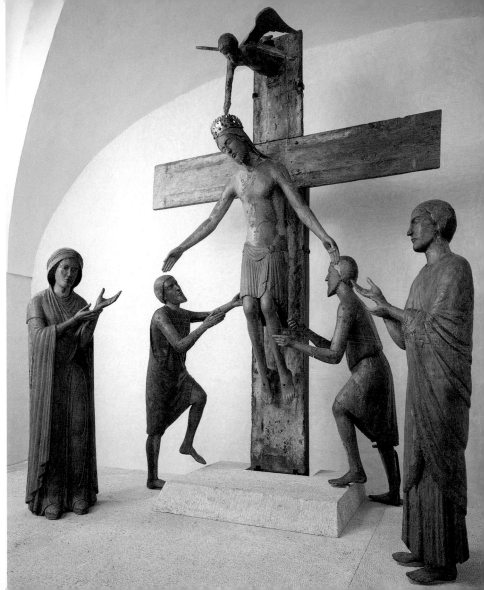

french school

ivory group

13th century

louvre, paris

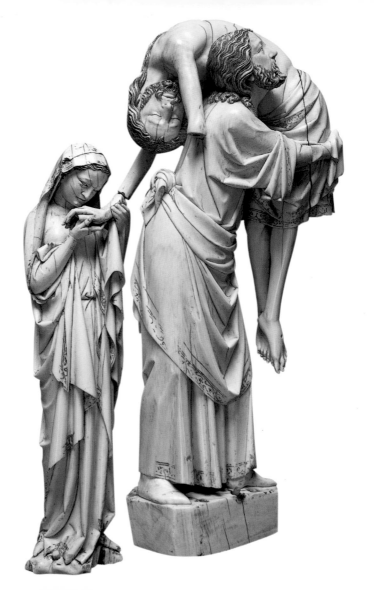

master of saint francis

tempera on wood

13th century

galleria nazionale dell'umbria, perugia

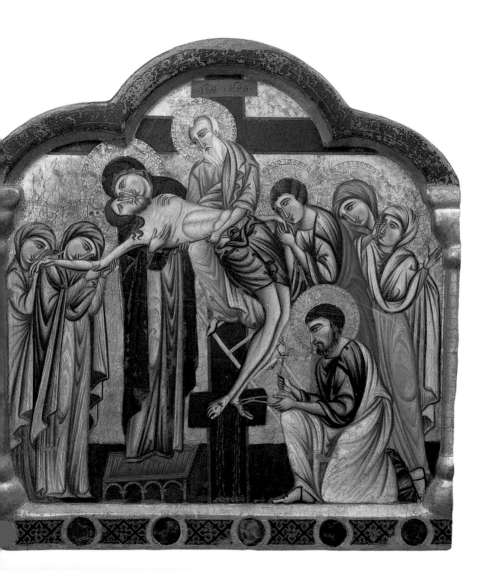

illuminated manuscript

c.1300

british library, london

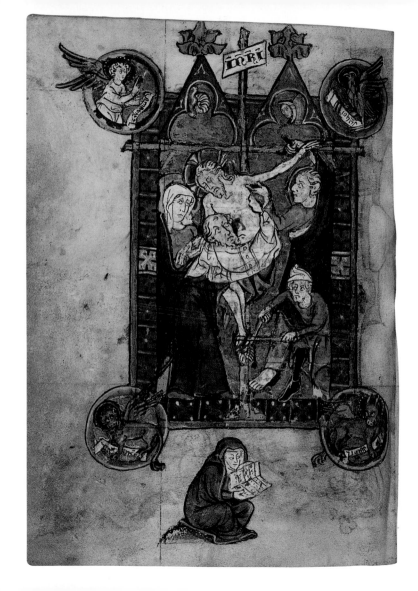

this panel by duccio, from his great 'maestà'
altarpiece, closely follows the contemporary
description of the descent from the cross
from the *meditationes vitae christi*, a series
of reflections upon the life of christ. these
were to exert a huge influence on later
medieval iconography.

duccio
tempera on wood
1308–11
museo dell'opera del duomo, siena

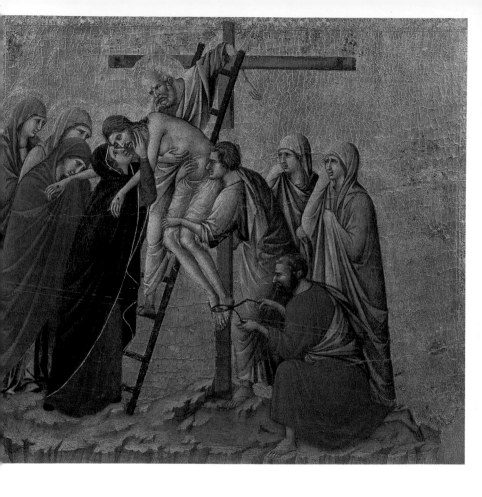

pietro lorenzetti

fresco

c.1315

san francesco, assisi

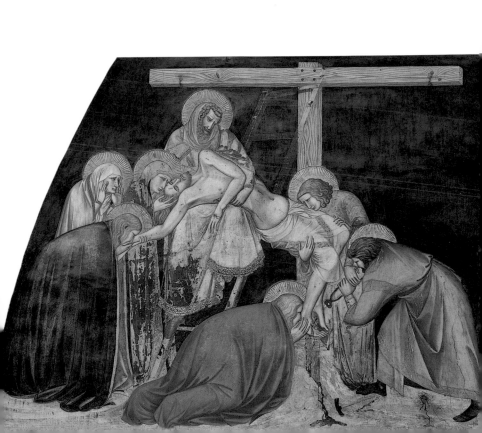

fresco

1317

staro nagoricino monastery

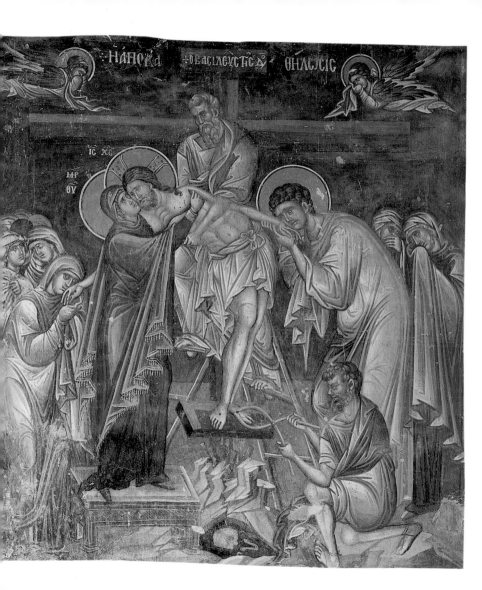

by the end of the thirteenth century artists
had begun to concentrate on the emotional
impact of the episode upon those present.
simone martini's image – with the evocative
gestures and facial expressions of the
women and the two youths who confront
each other at the foot of the cross – marks a
vivid departure from the more formal,
restrained compositions of earlier works.

simone martini
tempera on panel
c.1320
koninklijk museum voor schone
kunsten, antwerp

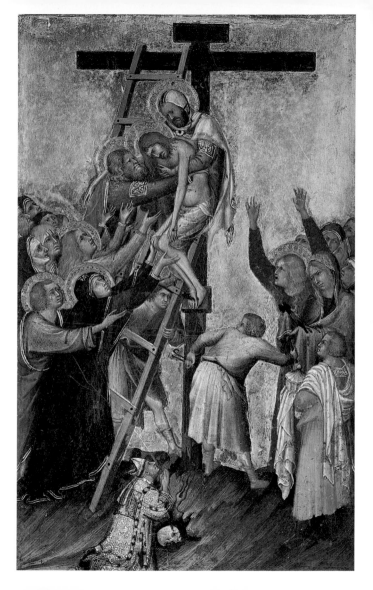

ugolino is recorded as working in siena in
the years following duccio's death, and it
seems probable that he initially trained in
duccio's workshop. their close similarity is
especially evident in this work by ugolino,
which clearly shows the influence of his
master's composition (p. 36).

ugolino di nerio
tempera on panel
c.1324–5
national gallery, london

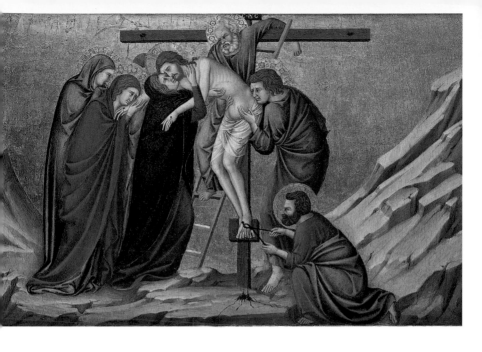

pietro da rimini

tempera on panel

c.1330–40

louvre, paris

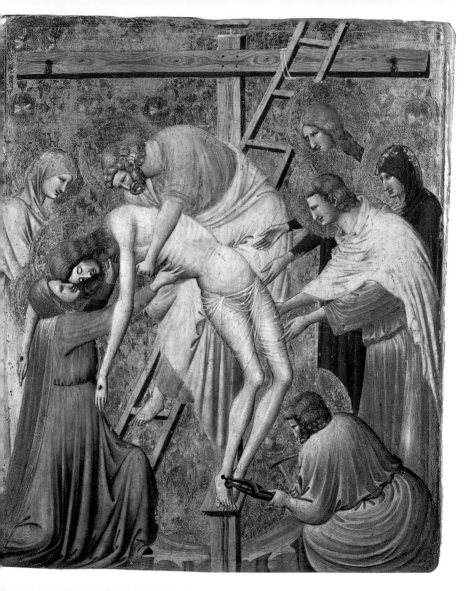

french school

ivory relief

c.1350–60

walker art gallery, liverpool

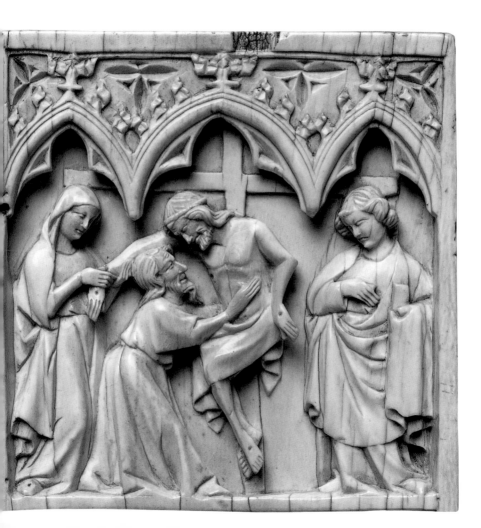

jean le noir

illuminated manuscript

c.1370–5

bibliothèque nationale, paris

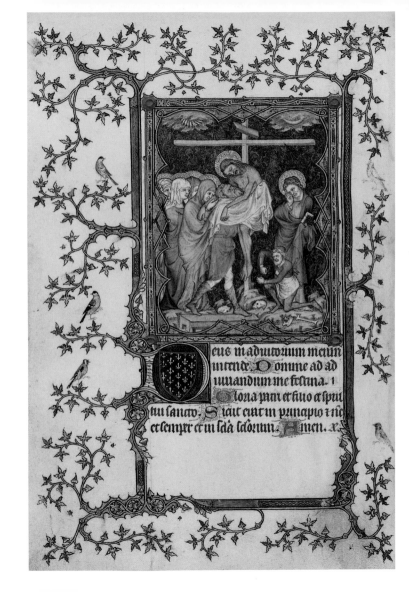

eus in adiutorium meum
intende. Domine ad ad
iuuandum me festina. 1
Gloria patri et filio et spiri
tui sancto. Sicut erat in principio et nc
et semper et in secula seculorum. Amen. x.

joseph can usually be distinguished from
nicodemus by his dress: the former
frequently wears elegant robes, with a
large purse at his belt, and is sometimes
hatted (as befits his reputation as a rich and
well-respected jew), while the latter is
normally of more humble appearance. here,
as often, joseph receives christ's body on
his shoulder.

english school
alabaster relief
early 15th century
victoria and albert museum, london

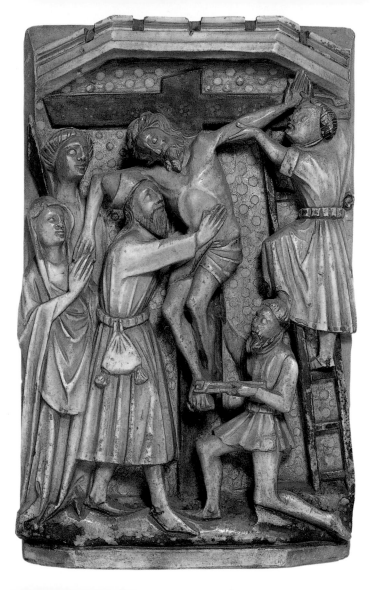

mary magdalene, clearly identifiable by her
long, flowing hair and fashionable dress, is
one of the main protagonists of the descent
from the cross. in the later sixteenth and
seventeenth centuries she came to occupy a
central position in the scene, since the
church held her up as an ideal example
of christian penitence.

paul and jean de limbourg
illuminated manuscript
c.1411–16
musée condé, chantilly

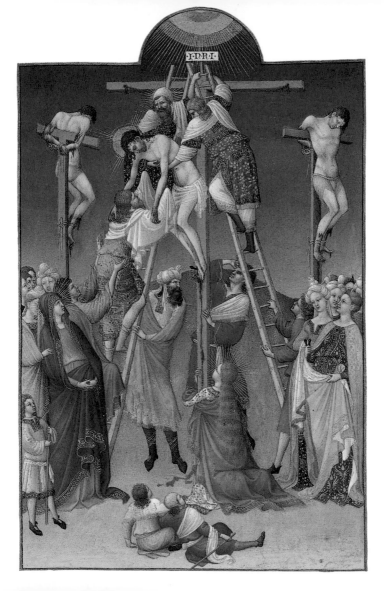

as well as the usual figures associated
with the crucifixion and descent (the two
maries, john, joseph and nicodemus), fra
angelico has included on the right portraits
of some of his contemporaries. the young
man kneeling opposite mary magdalene
before the cross has been identified as
giovanni gualberto, founder of the order
of vallombrosians for whose church this
altarpiece was painted.

fra angelico
tempera on wood
1433–4
museo di san marco, florence

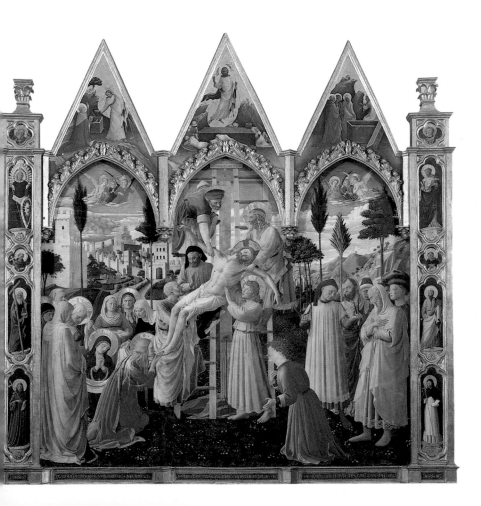

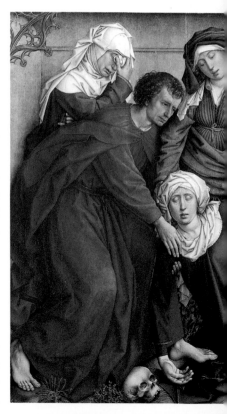

in rogier van der weyden's magnificently
composed altarpiece, the shape and position
of christ's body, held by nicodemus and
joseph, is almost exactly paralleled by that
of the virgin who has collapsed at the foot of
the cross. the artist is making an allusion to
the legend that at the crucifixion christ's
mother shared in the agony of her son.

rogier van der weyden
oil on wood
c.1435
prado, madrid

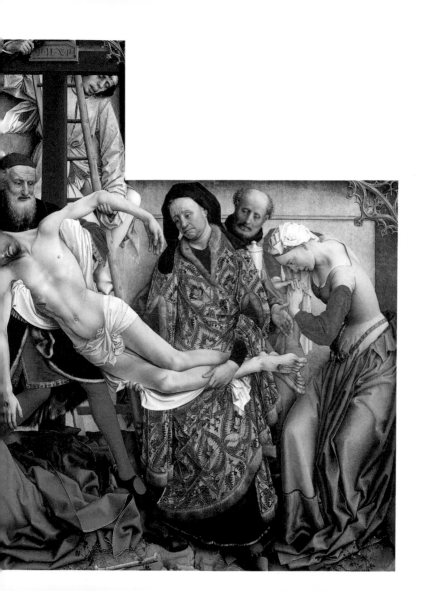

master of catherine of cleves

illuminated manuscript

c.1440

pierpont morgan library, new york

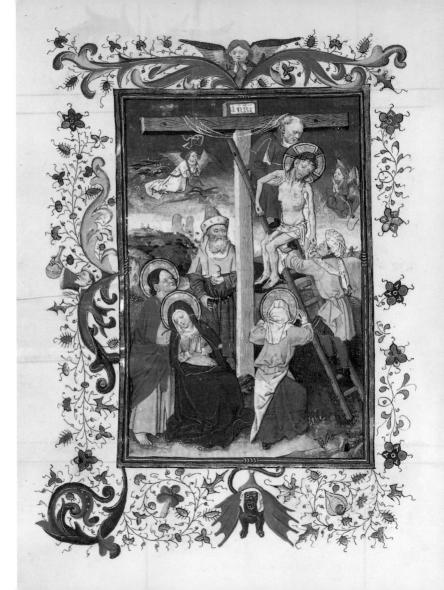

by the mid-fifteenth century, the increased
number of characters involved in removing
christ's body from the cross meant that a
second ladder was frequently called for.
artists such as jean fouquet and mantegna
(overleaf) were quick to exploit the
opportunity for neat, symmetrical
compositions which it afforded. later as
many as four ladders were employed to
great dramatic effect (p. 154).

jean fouquet
illuminated manuscript
c.1452
musée condé, chantilly

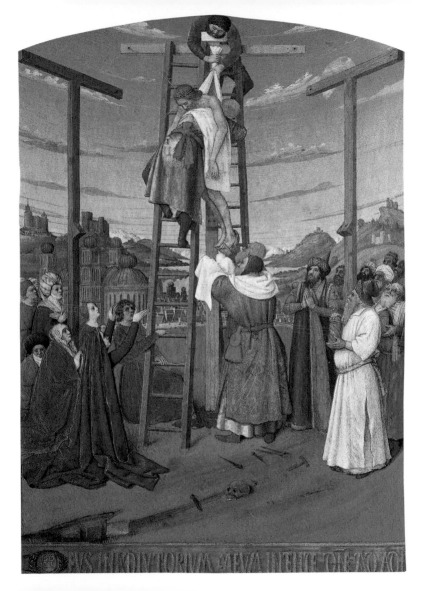

andrea mantegna

engraving

1456–9

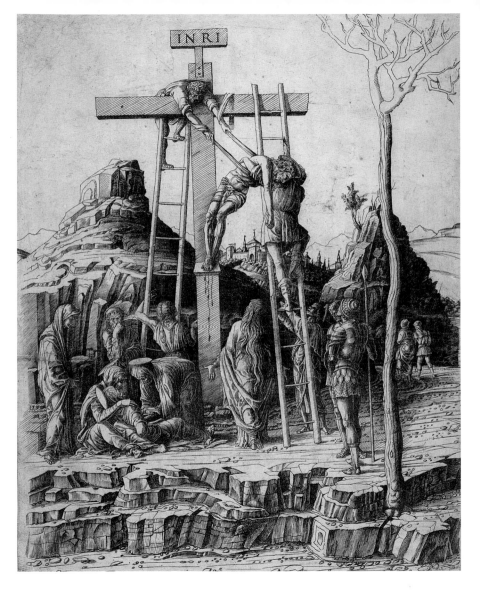

dirck bouts

oil on wood

1450s

capilla real, granada

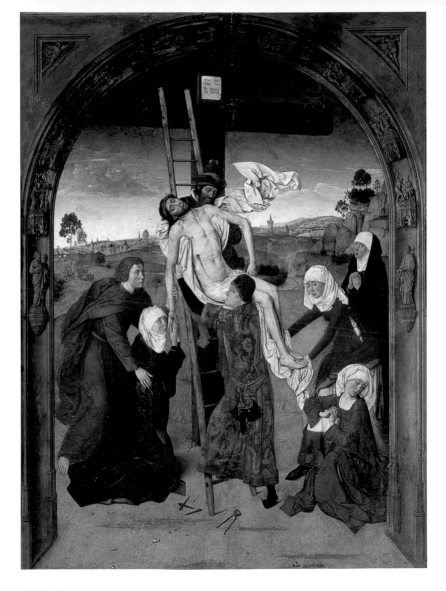

hans pleydenwurff

oil and tempera on wood

1462

germanisches nationalmuseum, nuremberg

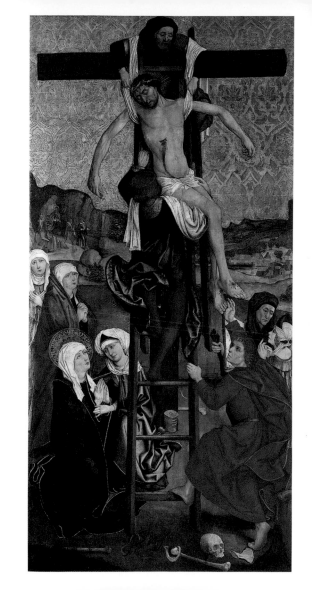

donatello

bronze relief

1460s

san lorenzo, florence

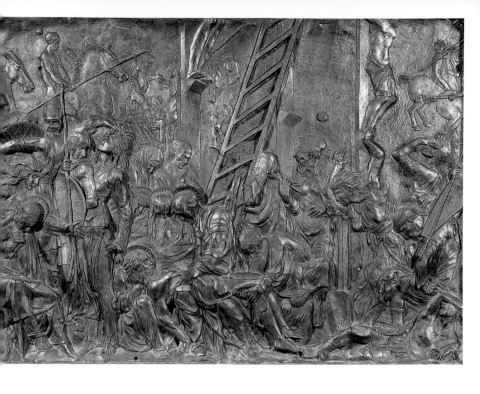

memling has reduced the episode of the
descent from the cross into a closely-
cropped ensemble – the three men who
support christ's body and a glimpse of the
ladder which leans against the cross – thus
accentuating the emotional impact of the
scene upon the viewer.

hans memling
oil on wood
1480–90
capilla real, granada

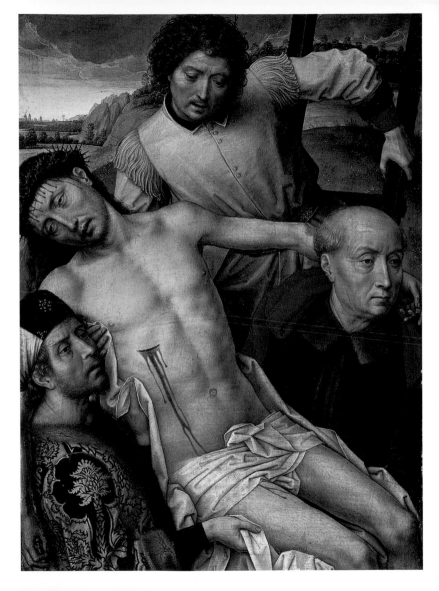

master of the legend of saint catherine

oil on wood

c.1490

wallraf-richartz museum, cologne

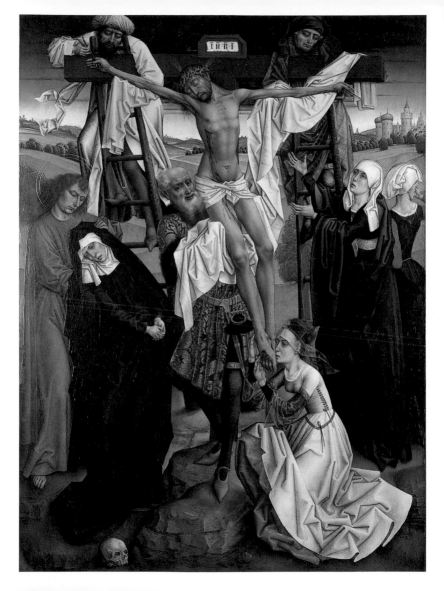

76

cosimo rosselli
oil and tempera on wood
c.1490–1500
museum of fine arts, boston

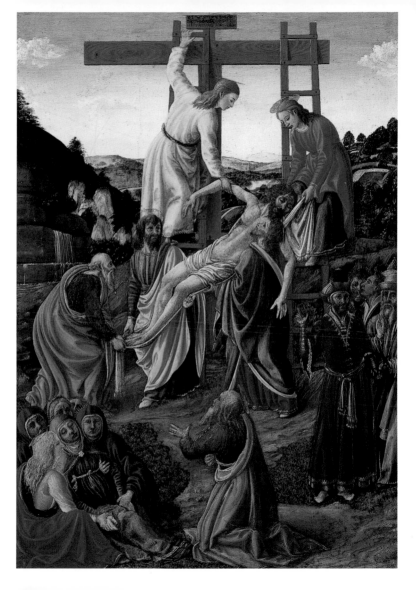

78

master of the older prayerbook of
maximilian i
illuminated manuscript
c.1497–1500
cleveland museum of art

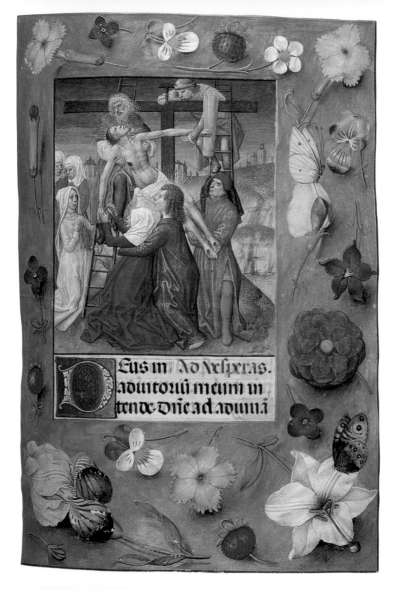

vranck van der stock
oil on wood
late 15th century
private collection

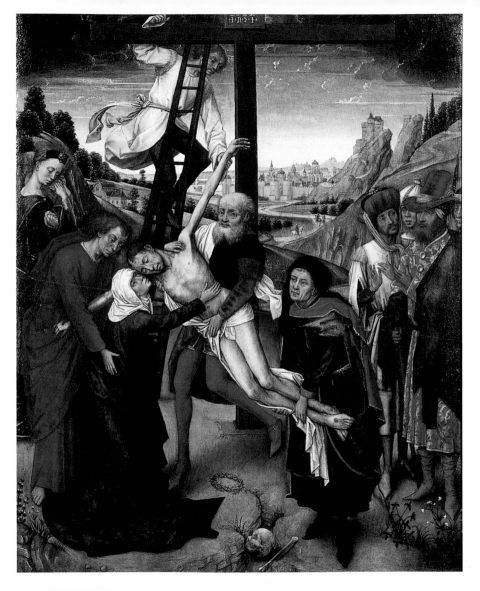

greek school

icon

c.1500

benaki museum, athens

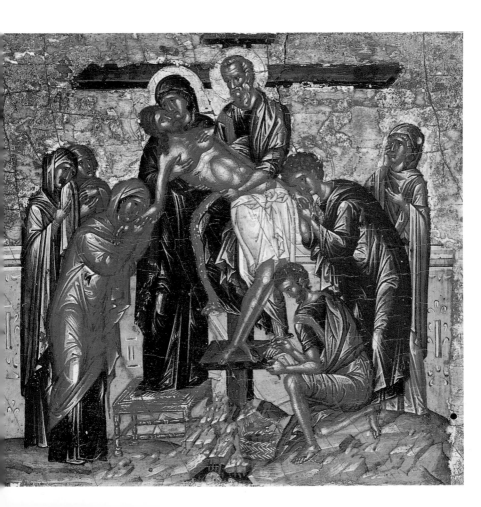

master of the saint bartholomew altarpiece

oil on wood

c.1500–5

national gallery, london

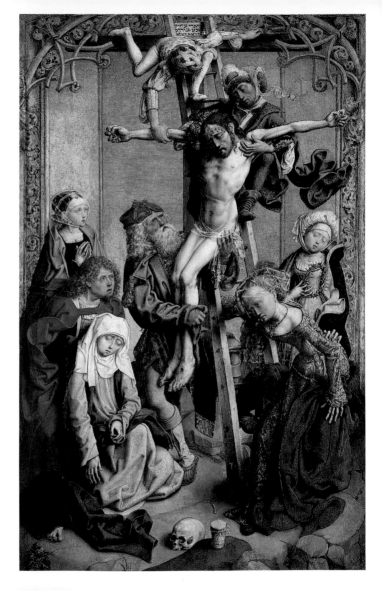

master of delft

oil on wood

c. 1500–10

national gallery, london

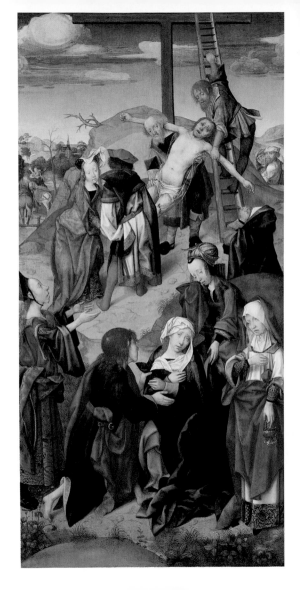

88

filippino lippi and pietro perugino

tempera on wood

c.1503–4

accademia, florence

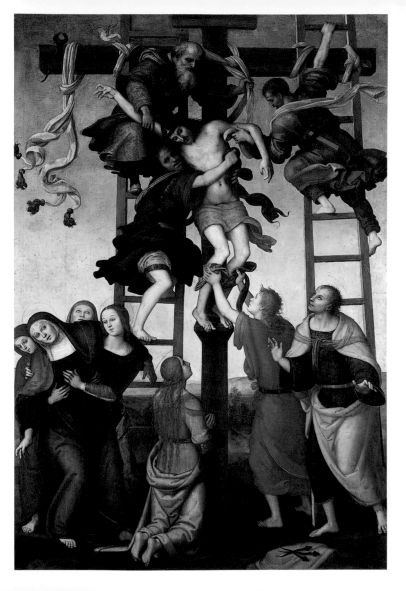

juan de borgoña

oil on wood

c.1505

museo de santa cruz, toledo

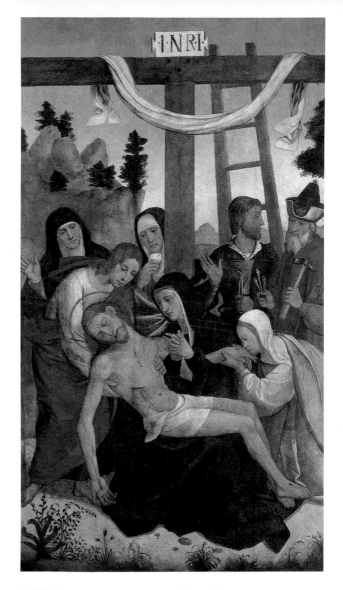

2

sodoma

oil on wood

c.1505–10

pinacoteca nazionale, siena

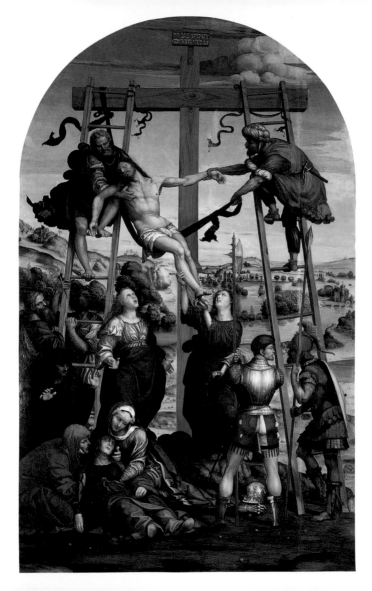

albrecht dürer

woodcut

1509

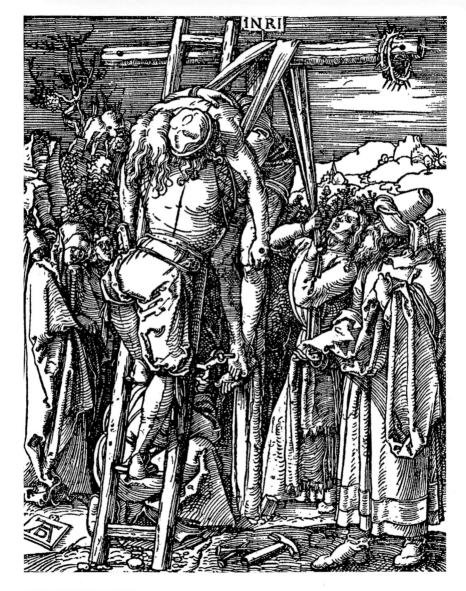

the composition of this picture is heavily
indebted to rogier van der weyden's great
masterpiece (p. 58). like him, the artist has
chosen to give the scene a highly artificial
setting, and the golden tracery and slight
stiffness of the figures lend it the air of a
polychrome gilt shrine.

master of the saint bartholomew altarpiece
oil on wood
c.1510
louvre, paris

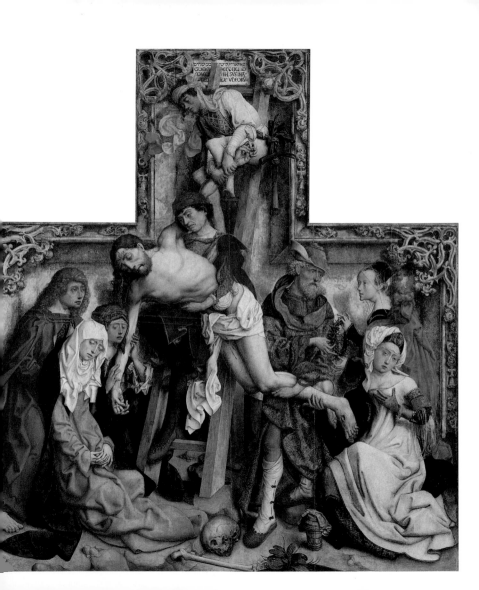

since joseph of arimathea was reputed to
be both wealthy and pious, he was often
represented in renaissance painting by a
portrait of the donor – here richly dressed
and looking out of the picture.

jan mostaert
oil on wood
c. 1510–16
musées royaux des beaux-arts
de belgique, brussels

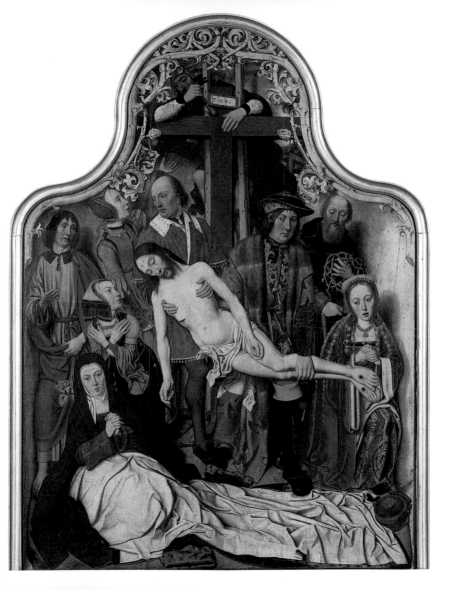

flemish school

tapestry

1511–18

trento cathedral

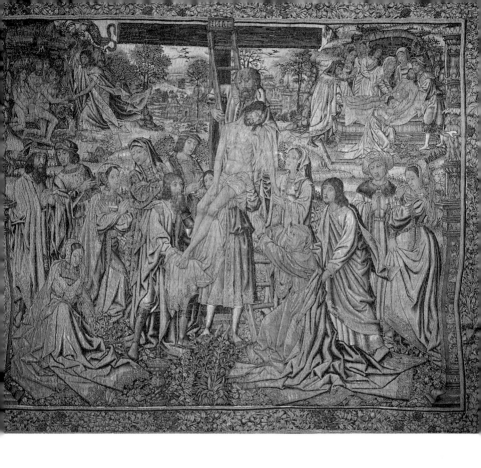

jacob claesz van utrecht

oil on wood

1513

gemäldegalerie, berlin

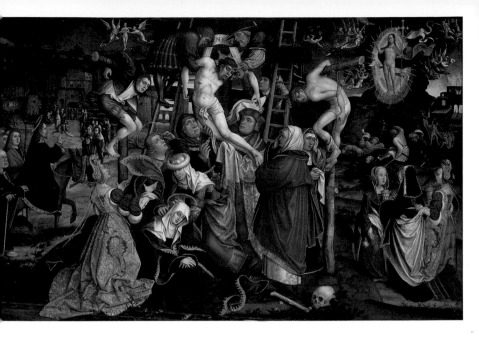

joos van cleve

oil on wood

c.1518

national gallery of scotland, edinburgh

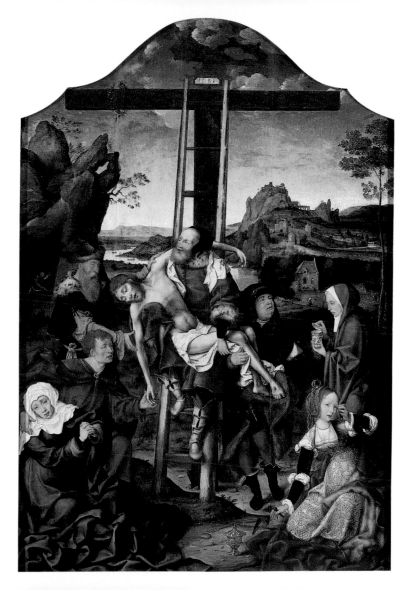

colyn de coter
oil and tempera on wood
1520
staatsgalerie, stuttgart

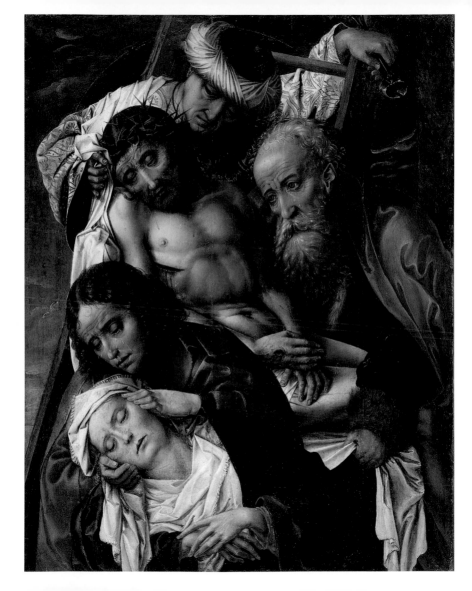

rosso's descent from the cross represents
a disturbing departure from the ideals of
the high renaissance, as classical balance
and harmony are rejected in favour of a
scene of nightmarish intensity. frozen,
angular figures, harshly lit and painted in
lurid colours, form a latticework of spidery
shapes against a darkened sky.

rosso fiorentino
oil on wood
1521
pinacoteca comunale, volterra

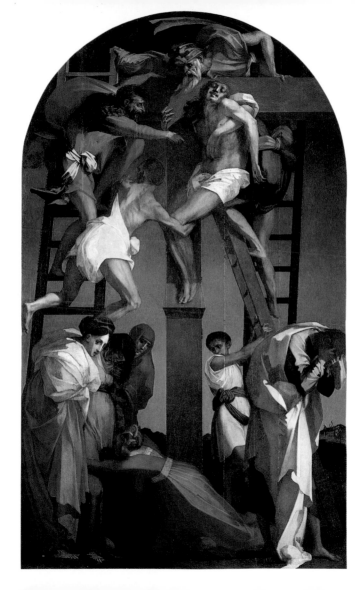

correggio

oil on canvas

c.1524

galleria nazionale, parma

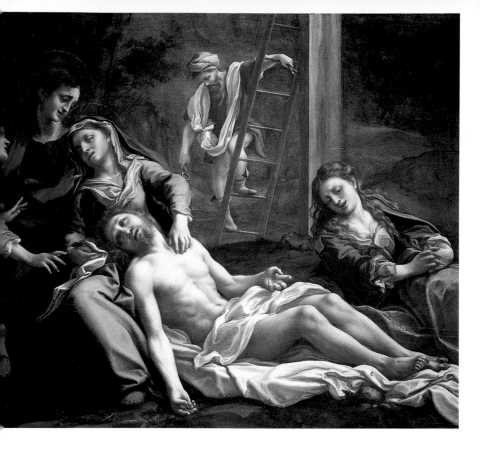

this is one of the greatest masterpieces of
mannerism, the movement which is
generally seen as a reaction against the
order and perfection of the high
renaissance. in pontormo's descent,
attenuated and seemingly adrogynous
figures appear almost to float in mid-air,
and its delicate lyricism and strange, pale
hues combine to create a haunting, other-
worldly expression of great sensitivity.

jacopo pontormo
oil on wood
1525–8
santa felicità, florence

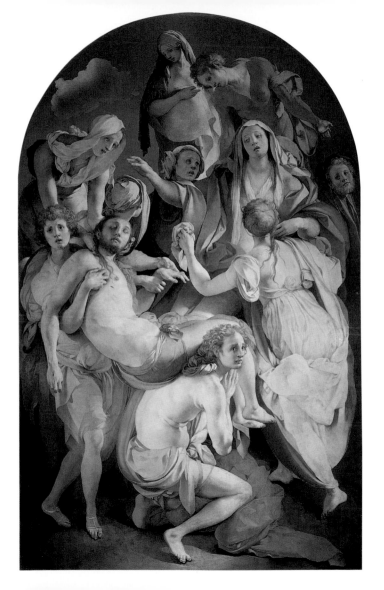

jan van hemessen

oil on wood

c.1526

musées royaux des beaux-arts

de belgique, brussels

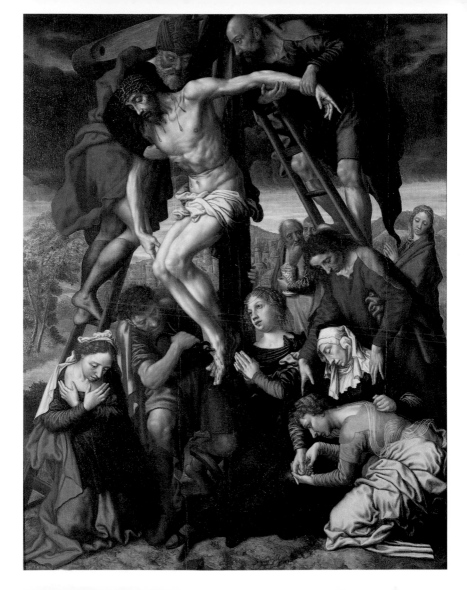

rosso fiorentino

oil on wood

1527–8

san lorenzo, sansepulcro

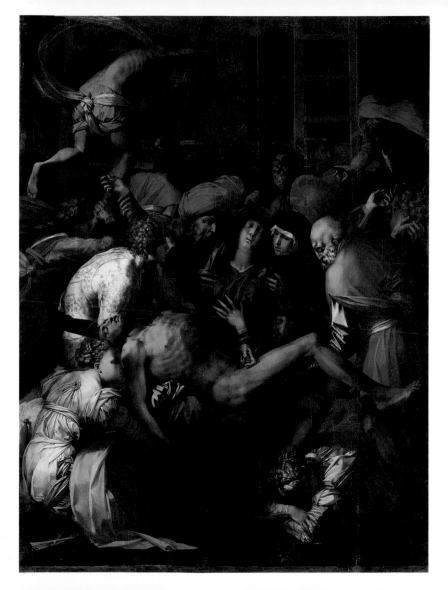

mabuse
oil on canvas transferred from wood
c.1530
hermitage, st petersburg

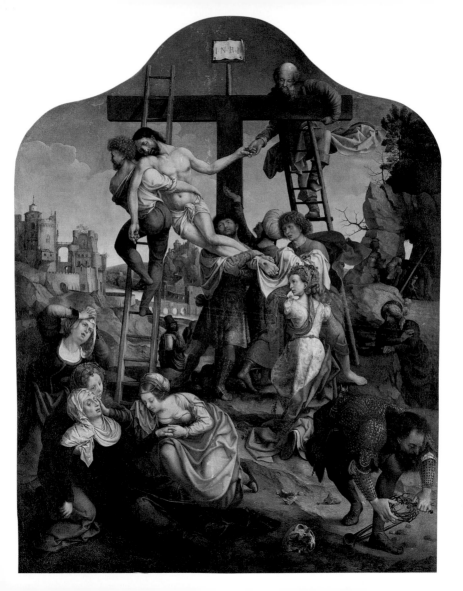

michelangelo

red chalk on paper

c.1533

teylers museum, haarlem

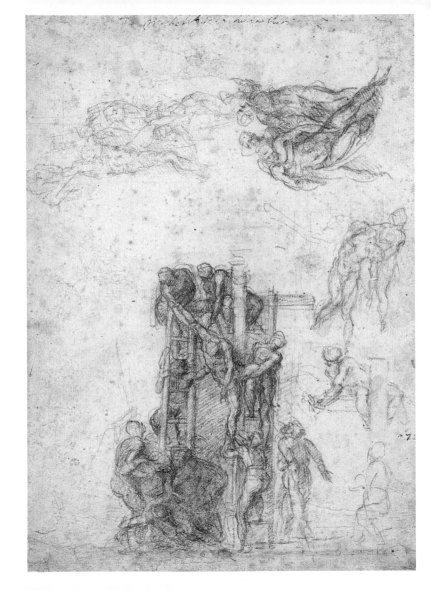

giorgio vasari

oil on wood

1540

santi donato e ilariano, camaldoli

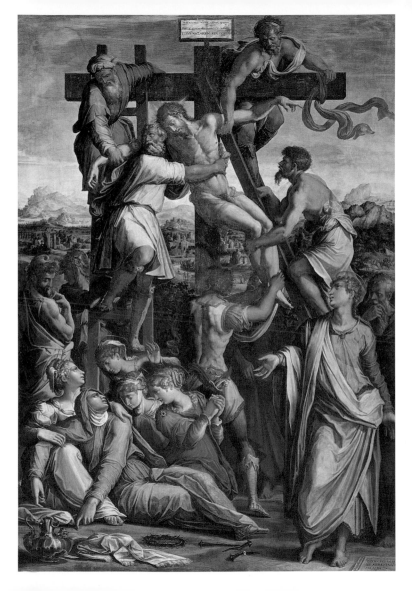

124

pedro machuca

oil on wood

1547

prado, madrid

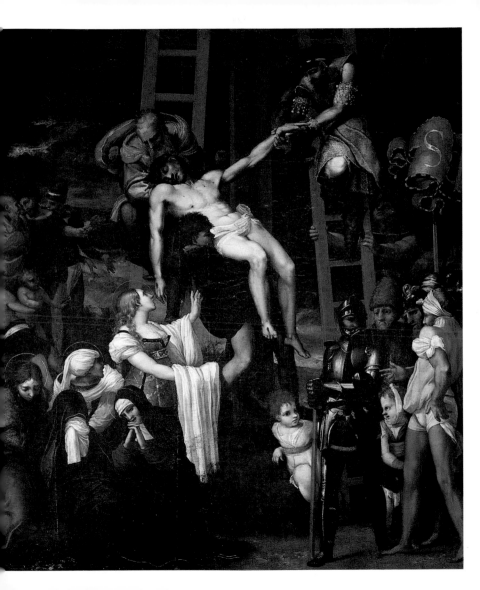

netherlandish school
oil on wood
mid-16th century
wernher collection, london

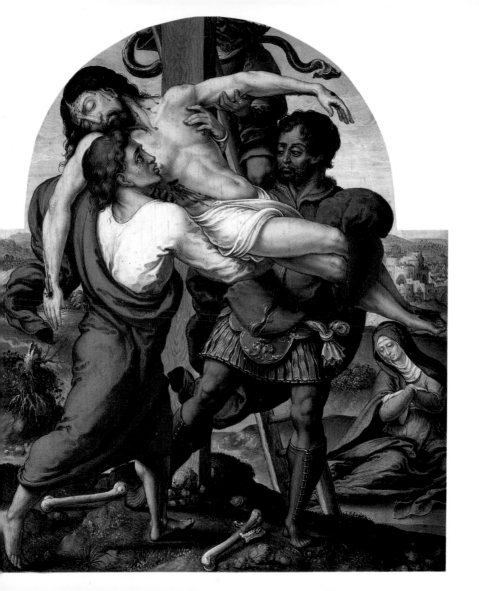

giuseppe salviati

oil on canvas

c.1555–60

san pietro martire, murano

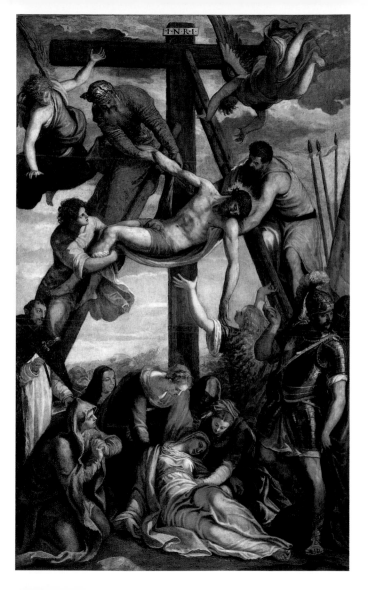

jacopo tintoretto

oil on canvas

c.1560

accademia, venice

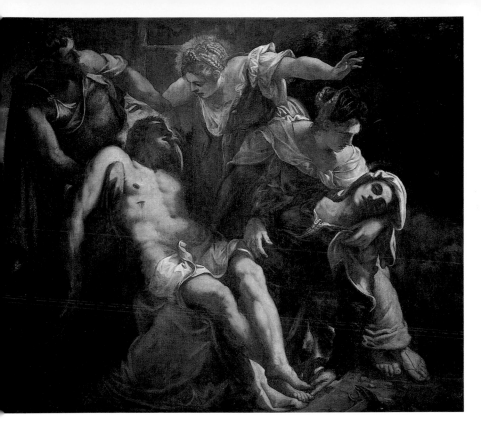

martin van heemskerck

engraving

c.1560

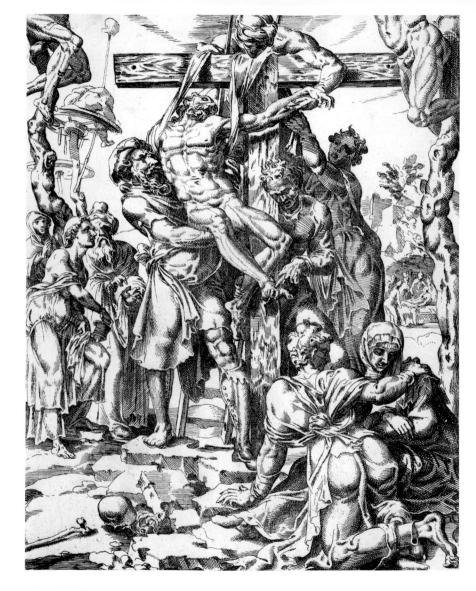

jacopo tintoretto

oil on canvas

c.1560–5

musée des beaux-arts, caen

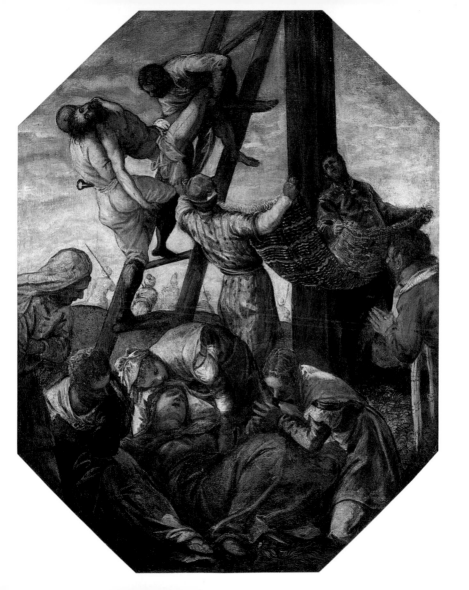

federico barocci

oil on canvas

1567

perugia cathedral

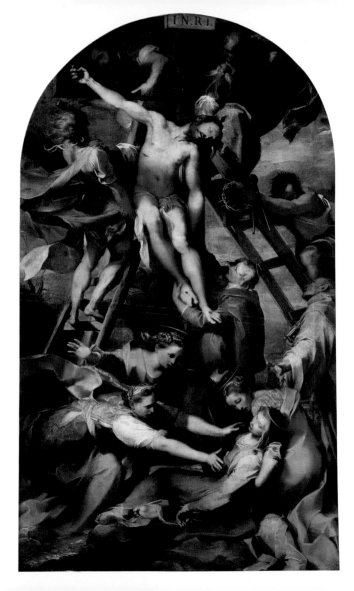

paolo veronese

oil on canvas

c.1580

escorial, madrid

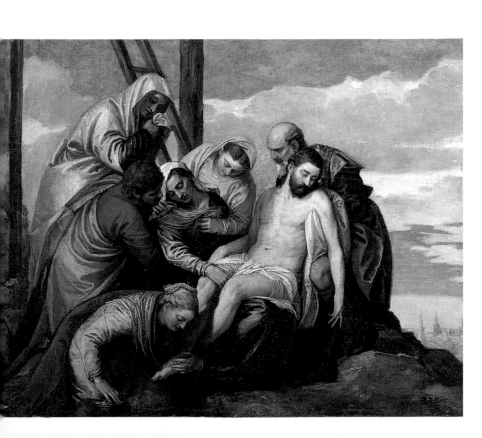

maerten de vos

engraving

c.1585

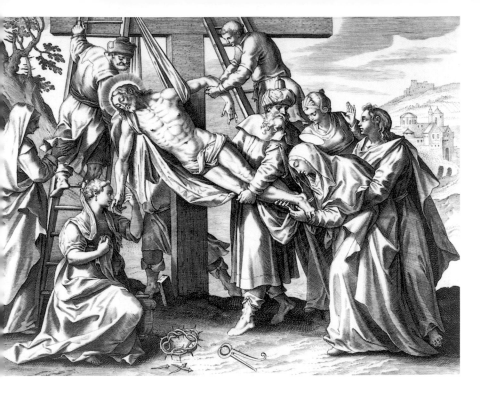

lodovico cigoli
oil on wood
1603–7
palazzo pitti, florence

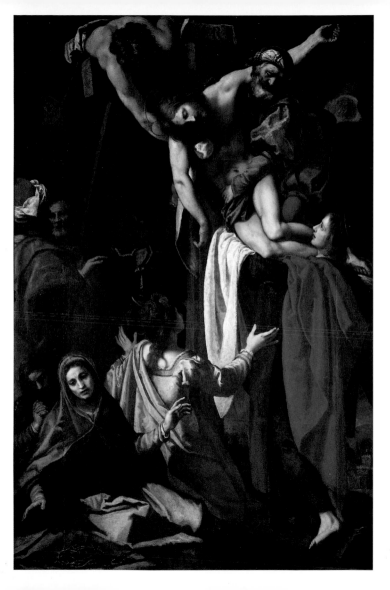

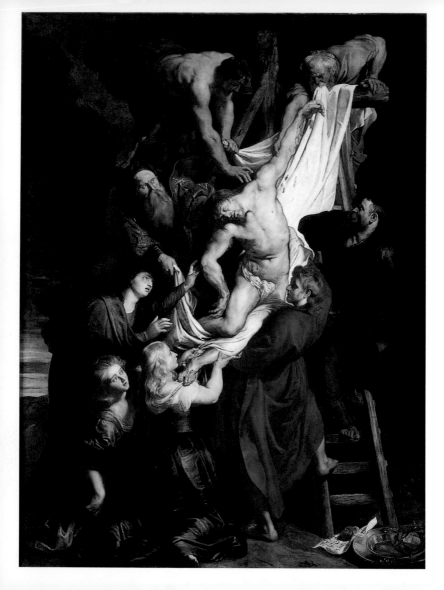

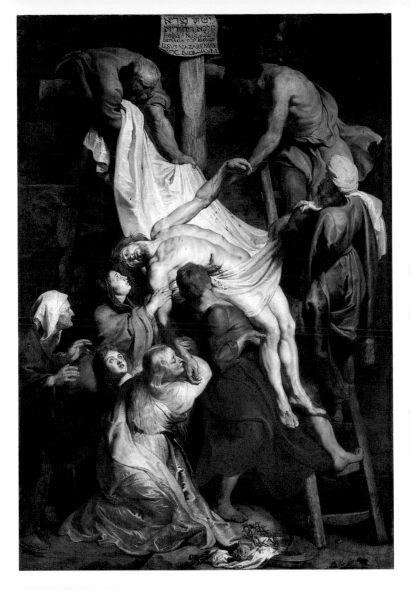

(previous pages)
peter paul rubens
oil on wood
1611–14
antwerp cathedral

peter paul rubens
oil on canvas
c.1617
musée des beaux-arts, lille

rutilio manetti
oil on canvas
c.1625
monte dei paschi collection, siena

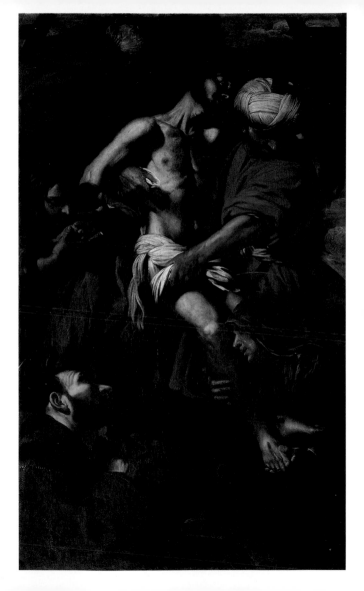

nicolas poussin

oil on canvas

c.1629–30

hermitage, st petersburg

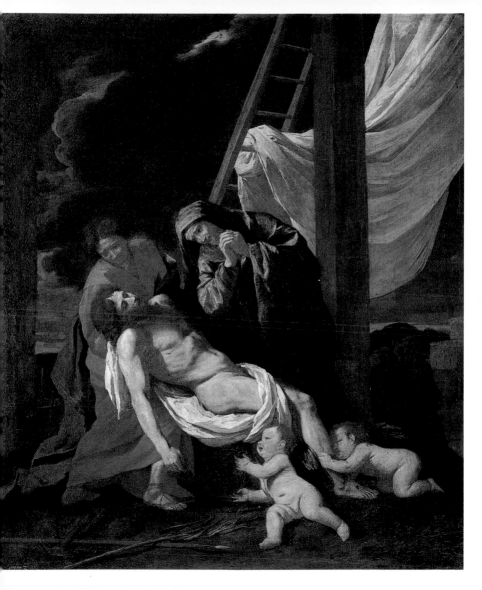

pieter fransz de grebber

oil on canvas

1633

rijksmuseum, amsterdam

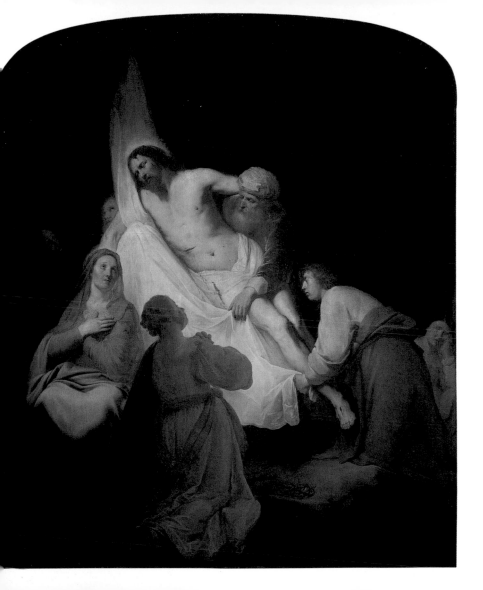

rembrandt here eschews the convention of
showing christ gracefully supported by his
attendants as his body is taken from the
cross, suggesting instead the lifeless weight
of the corpse.

rembrandt
oil on wood
c.1633–4
alte pinakothek, munich

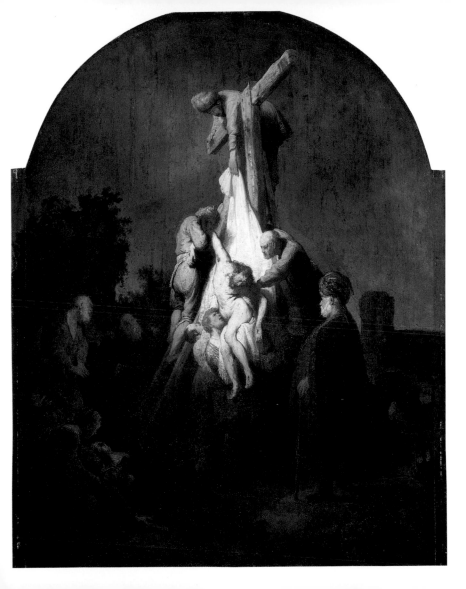

in about 1541 daniele da volterra, a pupil
of michelangelo, painted a fresco of the
descent in the church of santa trinità dei
monti, rome. the powerful but elegant
composition remained highly influential
well into the following century (as this
copy shows), and can be seen reflected in
versions by barocci, rubens and charles le
brun (pp. 136, 144 and 158). the original is
now sadly in a poor condition.

french school
oil on wood
c.1640
hatton gallery, university of newcastle

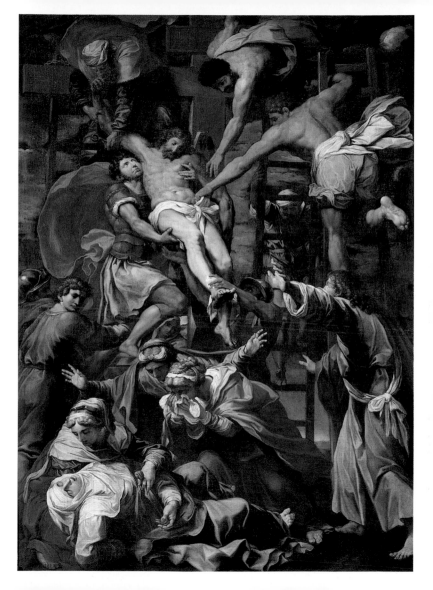

georg petel

ivory relief

1643

nationalmuseum, copenhagen

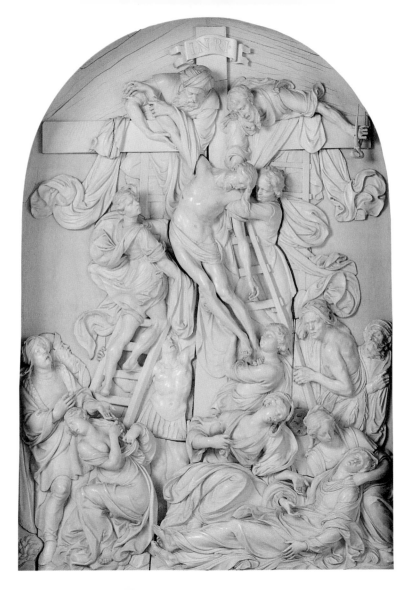

charles le brun

oil on canvas

c.1645

musée des beaux-arts, rennes

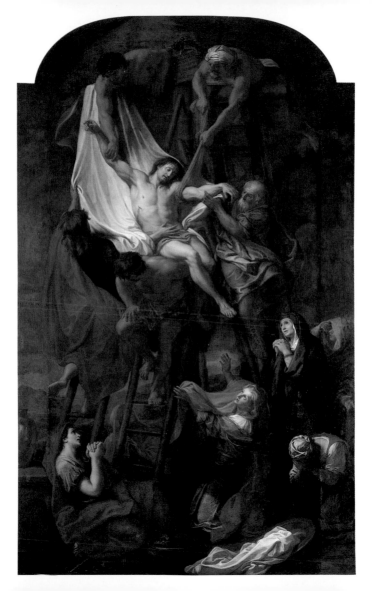

sebastien bourdon

oil on canvas

c.1650

louvre, paris

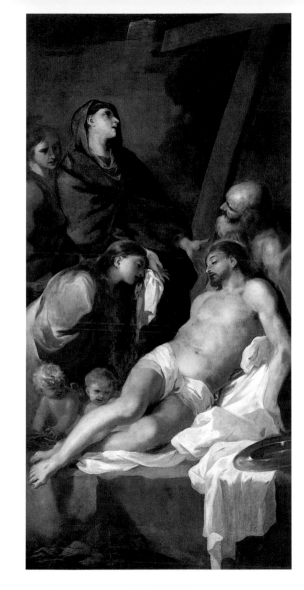

eustache le sueur

oil on canvas

c.1651

louvre, paris

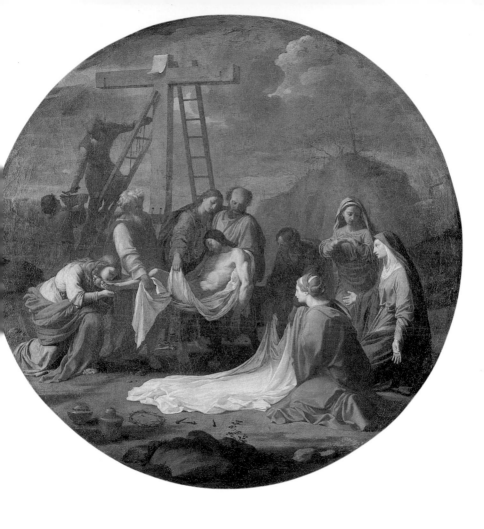

rembrandt

etching

1654

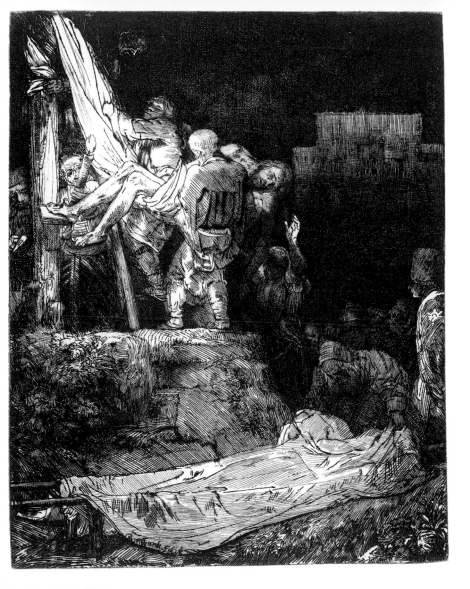

rembrandt

oil on canvas

c.1655

national gallery of art, washington dc

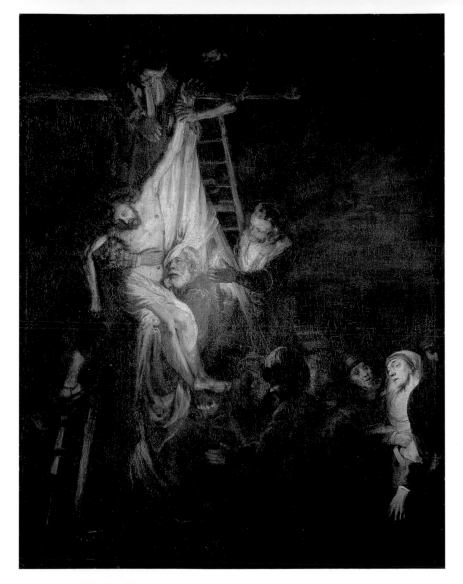

jean-baptiste jouvenet

oil on canvas

1697

louvre, paris

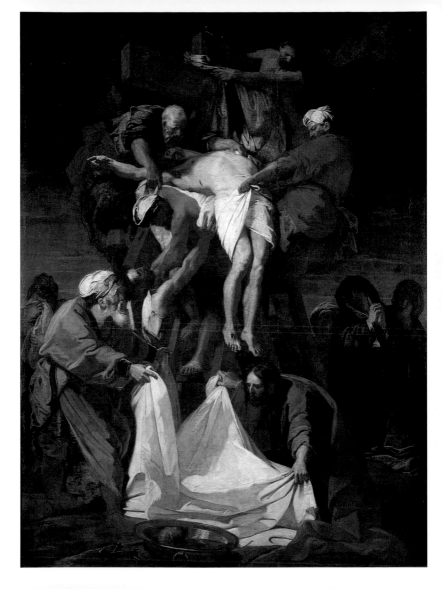

agostino cornacchini

marble

1714–16

biblioteca fabroniana, pistoia

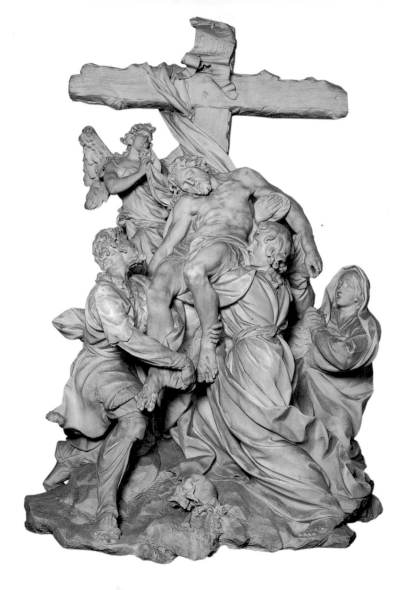

giovanni battista pittoni

oil on canvas

c.1750

m h de young memorial museum,

san francisco

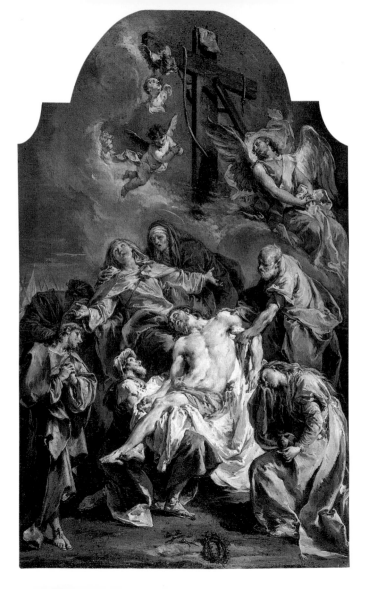

giuseppe bazzani

oil on canvas

c.1750

national gallery of ireland, dublin

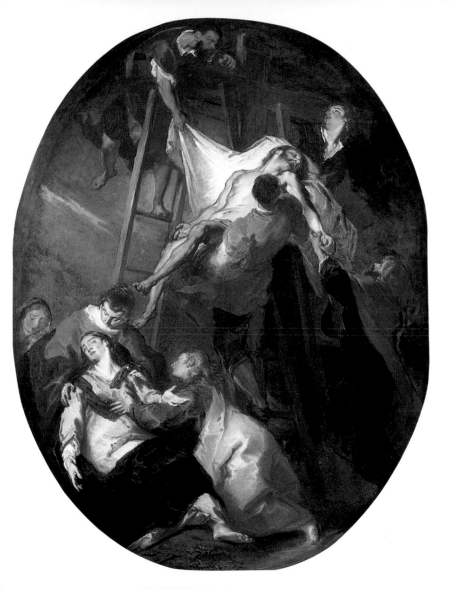

176

giovanni domenico tiepolo

oil on canvas

c.1750–60

national gallery, london

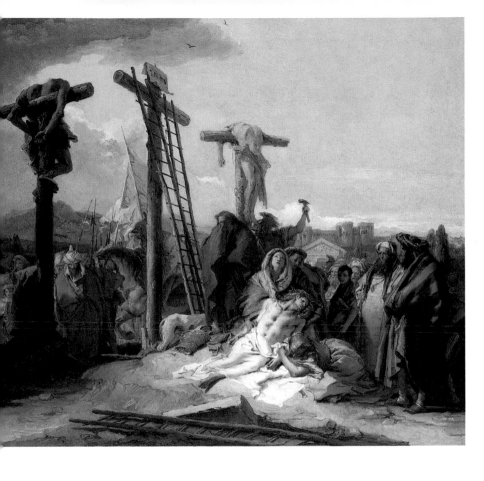

jean-baptiste regnault

oil on canvas

1789

louvre, paris

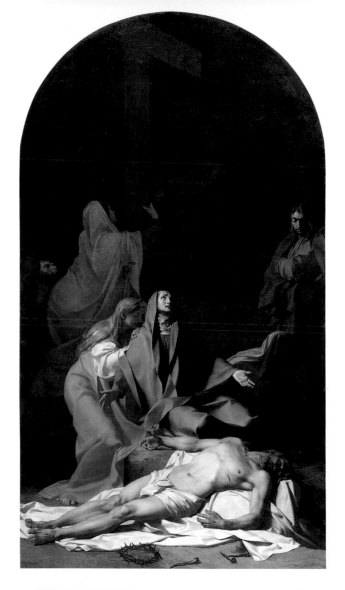

ernest hébert

oil on canvas

c.1840

musée hébert, paris

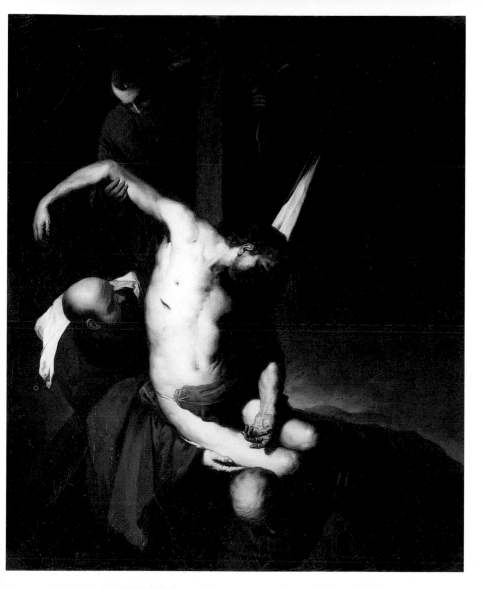

théodore chassériau
oil on canvas
1852–3
musée d'orsay, paris

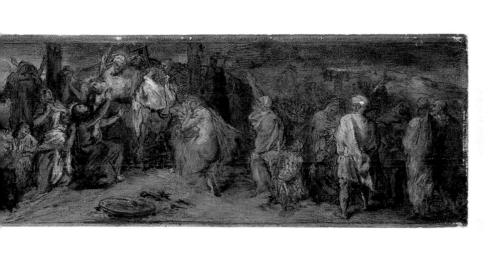

arnold böcklin

tempera on wood

1876

nationalgalerie, berlin

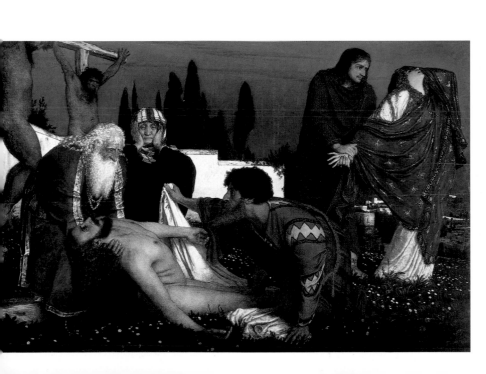

paul gauguin
oil on canvas
1889
musées royaux des beaux-arts de
belgique, brussels

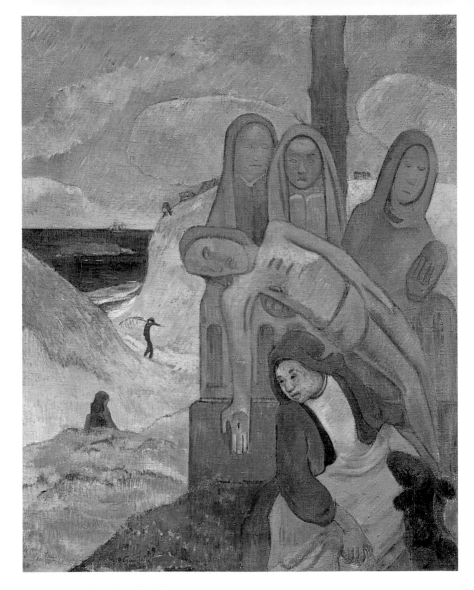

lovis corinth

oil on canvas

1895

wallraf-richartz museum, cologne

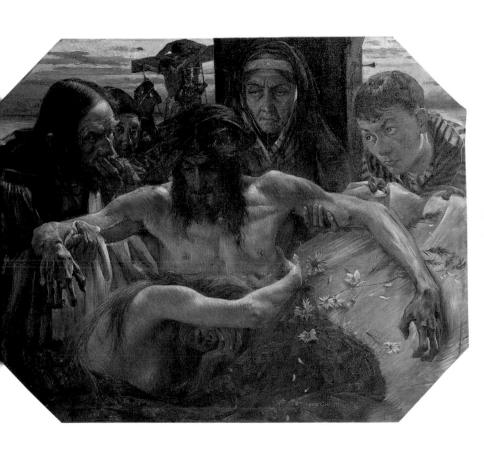

max beckmann's uncompromisingly bleak
descent, painted towards the end of the first
world war, has none of the compassion or
hope of redemption that characterized
medieval and renaissance treatments of the
same theme. his stiff, emaciated, jaundiced
christ affords little promise of resurrection.

max beckmann
oil on wood
1917
museum of modern art, new york

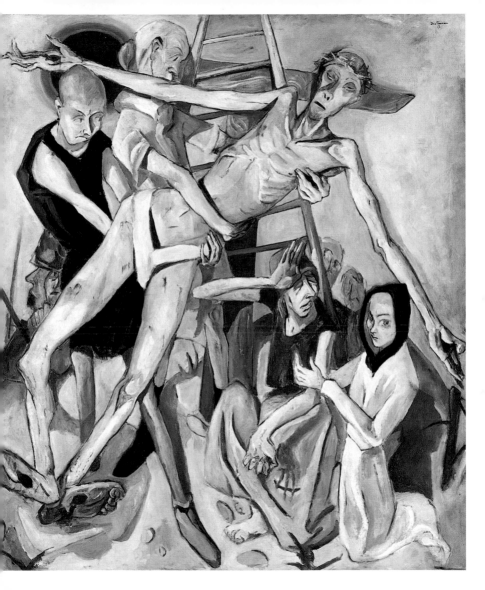

eric gill

marble

1924

the king's school, canterbury

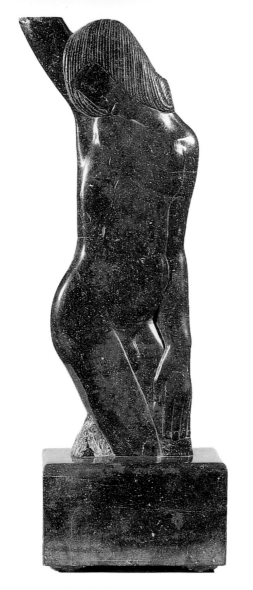

eric gill

wood engraving

1931

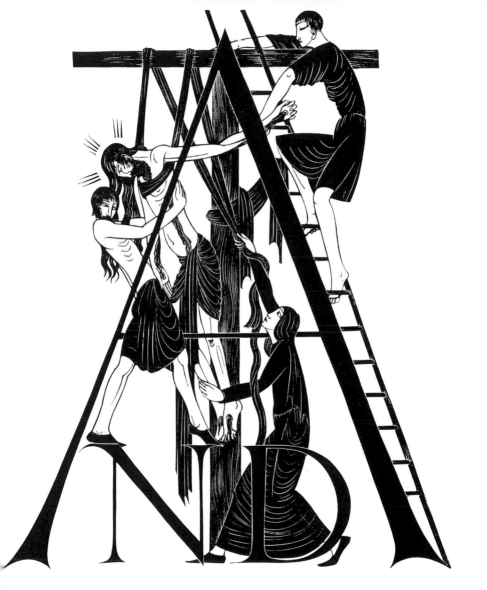

manzù was to return to scenes of the
passion several times throughout his career,
even after embracing marxism during the
second world war.

giacomo manzù
bronze relief
1933
private collection

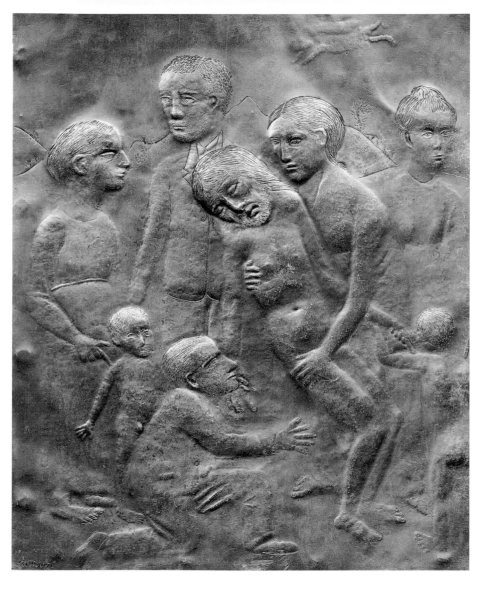

william h johnson
oil on board
c.1939
national museum of american art,
washington dc

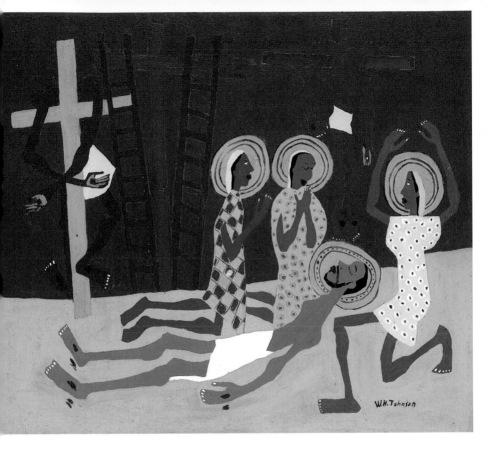

for the figure of mary magdalene, in her
usual position at the foot of the cross,
sutherland drew inspiration from the
grieving women in picasso's *guernica*.

graham sutherland
oil on board
1946
fitzwilliam museum, cambridge

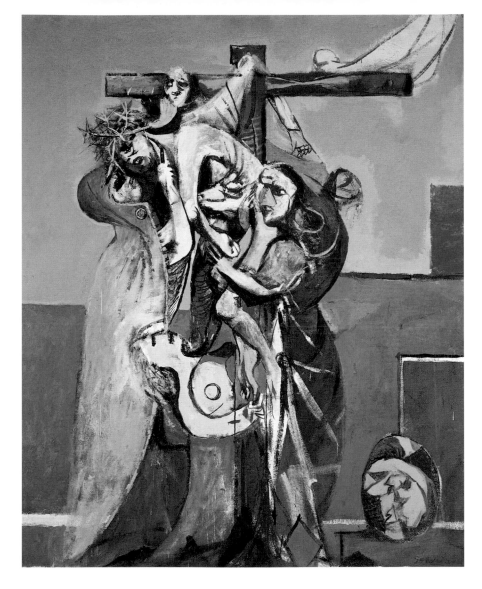

giacomo manzù

bronze relief

1951

openluchtmuseum beeldhouwkunst

middelheim, antwerp

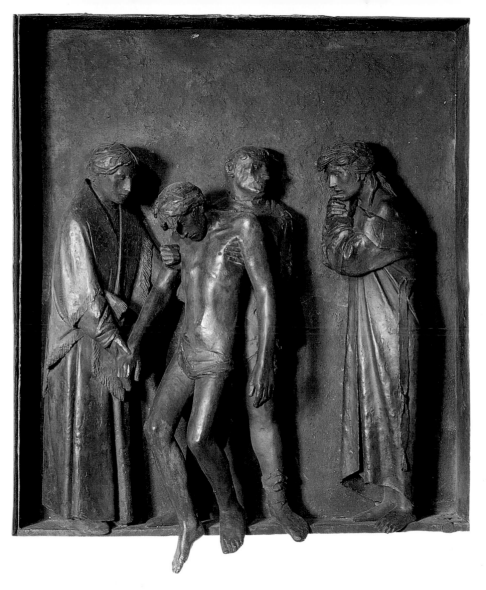

stanley spencer

oil on canvas

1956

york city art gallery

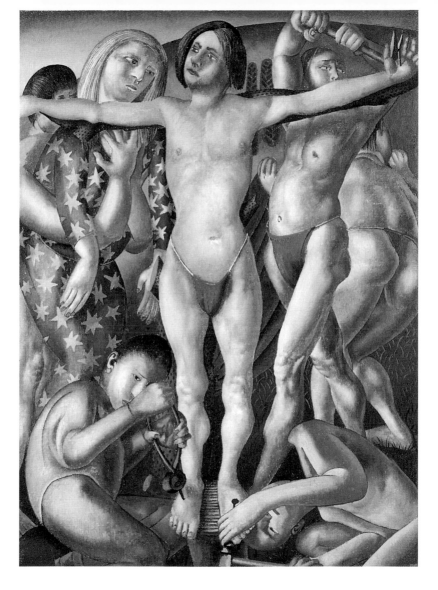

2

06

barnett newman is one of the few artists
to have produced an entirely abstract
interpretation of the stations of the cross,
the fourteen episodes dealing with christ's
crucifixion, of which the descent from the
cross is number thirteen.

barnett newman
acrylic on canvas
1966
national gallery of art, washington dc

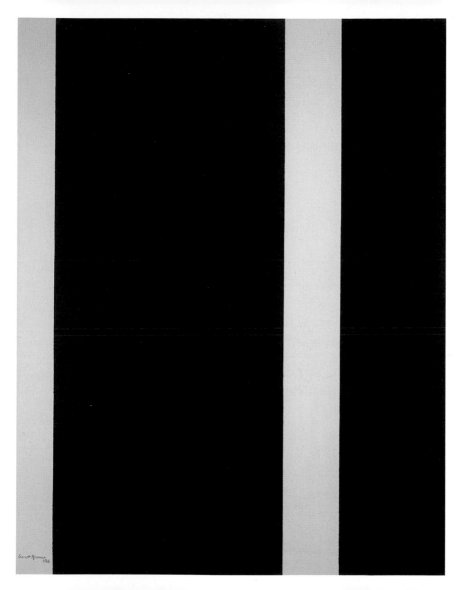

marc chagall

oil on canvas

1968–76

musée message biblique marc chagall, nice

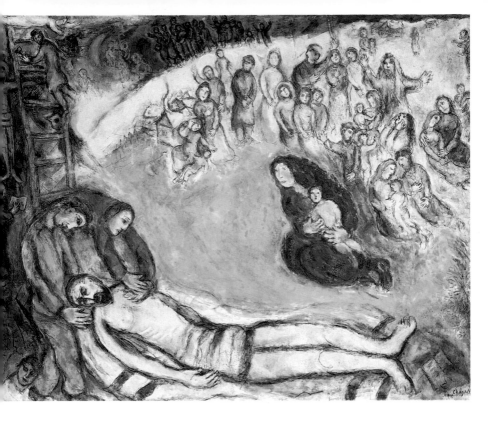

steve hawley
oil and resin on wood
1988–90
st louis cathedral

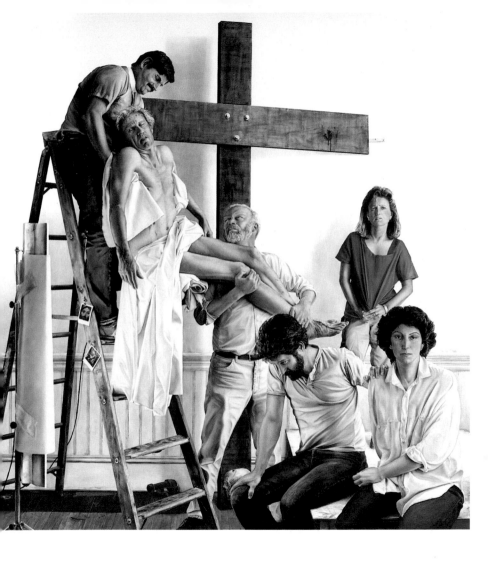

caro uses a bronze sheet to replicate
the effect of the long white shroud that
dominates the centre of rembrandt's
painting in munich (p. 152), the work
which inspired this modern interpretation
of the theme.

anthony caro
brass and bronze, cast and welded
1989–90
private collection

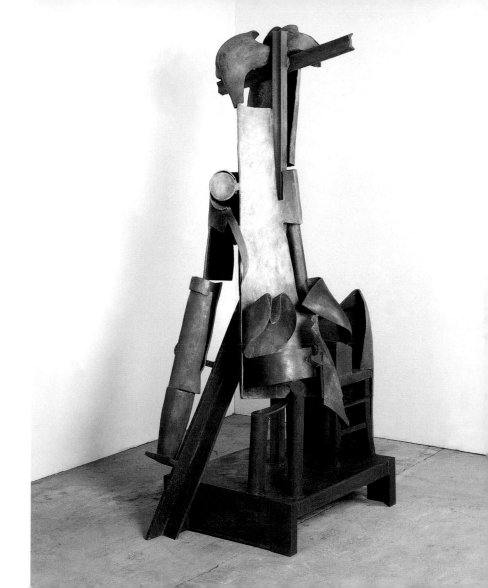